one million days in

China

Main front cover image:
Figure of a luohan
Stoneware decorated with enamels
Ming dynasty, Chenghua period (1465–87),
dated 1484

Inside back cover image:
Plate
Porcelain with overglaze famille rose enamels
colours
Qing dynasty, Yongzheng period (1723–35)

This dish is part of the Jack Outhwaite Thompson bequest, bought through the National Arts Collection Fund in 2003.

© Text and images Glasgow City Council (Museums), 2004, unless otherwise acknowledged.

Photograph page 16 © John Swire & Sons Ltd, reproduced by kind permission.
Images page 25 & 58 © The Trustees of the National Museums of Scotland, reproduced by kind permission.
Image page 18 © The Oriental Museum, University of Durham, reproduced by kind permission.
Map page 46 reproduced by kind permission of Glasgow University Library Services.

© Design and typography Glasgow City Council (Museums), 2004.

Text by Emma Leighton with Nick Pearce

Cover printed on Zen Pure White 300gsm, text printed on Zen Pure White 150gsm, supplied by GF Smith, Lockwood Street, Hull HU2 0HL.

Printed in Scotland Published 2004 by Glasgow Museums ISBN 0 902752 76 6

CONTENTS

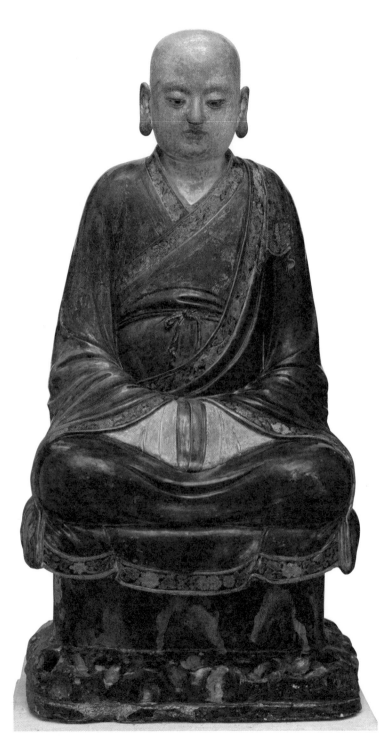

Figure of a Luohan
Stoneware decorated with enamels
Ming dynasty, Chenghua period (1465–87),
dated 1484

Luohan are Buddhist disciples who have attained
wisdom but who remain on earth to help others gain
enlightenment. In China there are 16, and sometimes
18, luohan represented in Buddhist temples. This
almost life-size figure of a seated Buddhist luohan
wears robes edged with an ornate floral border. He
sits in serene contemplation, cross-legged, with hands
folded in his lap. The inscription on the side of the
pedestal of this figure tells us that Liu Zhen made it
in 1484 for the Wang family, who would have paid
for it and its installation in the temple.

FOREWORD

Of the 8,000 objects which Sir William and Lady Constance Burrell generously gifted to the City of Glasgow in 1944, almost one quarter are Chinese in origin. We are delighted to be able to display some of the finest, many for the first time, in *One Million Days in China*.

Sir William's interest in China may have stemmed from his shipping interests or his family connections with the East. His knowledge, memory, contacts and good eye for art meant that he was a very successful buyer, and the Chinese collection is acknowledged to rank among the best collections held by European museums.

Glasgow and Scotland have a long history of trade with, and travel to, China. We are privileged to have had the assistance of the Chinese-Scots community in Glasgow in the organization of this exhibition – a relationship we are confident will continue to blossom not just with museums but with the whole of Cultural and Leisure Services. I hope that *One Million Days in China exhibition* and the associated activities and workshops will enable the people of Glasgow and visitors to the City to appreciate something of the rich culture of the oldest continuous civilization in the world. We are grateful to the Scottish Executive, without whose financial support this wonderful material could not have been presented so well to the people of Scotland and to visitors to our country.

Councillor John Lynch
Convener, Cultural and Leisure Services
Glasgow City Council

PREFACE

Sir William Burrell's collection of Chinese art is invaluable as an insight into what life and society was like in ancient China. Of the 150 objects in the *One Million Days in China* exhibition, 90 per cent are on display for the first time. The exhibition explores and celebrates Sir William Burrell's Chinese collection by revealing the history, culture and beliefs associated with the making of each object. It looks at the archaeology of ancient China, how Chinese writing began, what people believed about life after death and why ancestors are worshipped. The exhibition also explores China's faiths, the trade routes, contact between China and the West, Communist China and today's Chinese community in Glasgow. We are delighted to be able to display major loans of oracle bones and lacquer wares from the National Museums of Scotland in Edinburgh, and beautiful jade burial carvings from the Oriental Museum in Durham.

Emma Leighton
Curator of Chinese and Oriental Civilizations
Glasgow Museums

SIR WILLIAM BURRELL'S
CHINESE ART COLLECTION

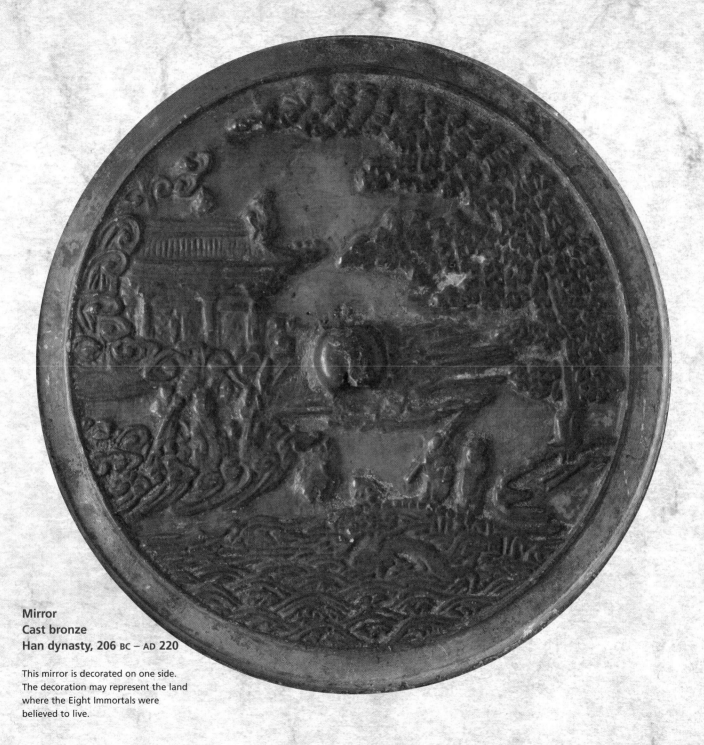

Mirror
Cast bronze
Han dynasty, 206 BC – AD 220

This mirror is decorated on one side.
The decoration may represent the land
where the Eight Immortals were
believed to live.

W hile looking at Sir William Burrell's world-class collection of 1,740 Chinese art objects, it is interesting to speculate on what may have aroused his fascination with China.

The third of seven children, William Burrell was born in Glasgow on 9 July 1861. His father and grandfather owned a successful Glasgow shipping firm and their ships travelled the world. Sir William Burrell's great-uncle George certainly had a link with China – he was Lieutenant General and the first British Governor of Hong Kong. Although Sir William never met George and never travelled to Asia, he spent many years of his life collecting Chinese art.

Burrell's acquisitions of Chinese art were undoubtedly very much influenced by the trends and interests within the London art market during the 1900s. He went regularly to auctions in London and built up contacts with many dealers whom he came to trust. When he approached dealers for the first time, he would conceal his identity for fear that if they knew who he was, the price would be inflated. A London dealer named Hans Calmann recalled his first encounter with Burrell in 1938. An old man shuffled into his shop one day and purchased, after much bargaining, a Chinese burial figure of a watchdog from the Han period and a vase. Only after the transaction was concluded did Burrell introduce himself. Calmann was very impressed by Burrell and considered that, unlike many other wealthy collectors, he had good judgement and knew what he wanted.

Sir William kept catalogues from most of the Chinese art auctions that he went to. These are a wonderful record of his enthusiasm. His purchase books contain a number of his sketches of Chinese

Bell
Cast bronze
Eastern Zhou dynasty,
771–481 BC

Music was an important part of Chinese ritual, and bells were sometimes consecrated in blood before being struck. This bell would have been part of a set of bells of different sizes and used as part of a ritual ceremony. In a later generation it was collected as an art object, at which time this elaborate wooden stand was made to display it.

pieces, but they are too rough, and the written descriptions too brief, for many of the acquisitions to be identified.

Sir William was particularly fond of Chinese bronzes, and he collected a total of 184. In one letter from 1947 he wrote, 'Chinese bronzes have always appeared to me to be far ahead of the Pottery-Stoneware or Porcelain with perhaps the exception of the Prehistoric pieces'.

The Chinese ceramics that were added to his collection between 1911 and 1916 were quite diverse, with the Zhou, Han, Tang, Ming and Qing dynasties each represented by a few pieces. Between the years 1945–49, when he was in his mid-eighties, Sir William became particularly interested in ancient Chinese art. He avidly collected ceramics, jades and bronzes, as he believed these aspects of his collection needed to be built up in order to make it complete. He stated his policy on many occasions: 'I think it is better to fill the gaps than bid for better specimens of what we already have'.

In 1944 Sir William gifted his entire collection of over 8,000 objects to his native city of Glasgow. However, his passion for collecting did not cease and he continued to collect Chinese works of art until he was 91. Up until the last few years of his life Sir William continued to go to auctions and visit dealers in London. A collector named King noted a wonderful conversation with Burrell. King was in a dealer's shop in Bury Street, London, and saw a rather fragile old man looking at an object. This prompted the following dialogue:

King: 'You are Scottish, Sir?'
Aged Gentleman: 'Aye'.
King: 'Do you know Sir William Burrell?'
Aged Gentleman: 'Aye, and I'm what's left of him!'

This dialogue underlines Burrell's unassuming character and his sheer determination as a collector.

At the end of 1948, Burrell decided that the Chinese section of his collection was virtually complete, and he made few purchases after that date, stopping completely in 1952. By then he had succeeded in forming one of the most important collections of Chinese art in Britain. Sir William died in 1958 at the grand age of 96 in Hutton Castle, his home near Berwick-upon-Tweed.

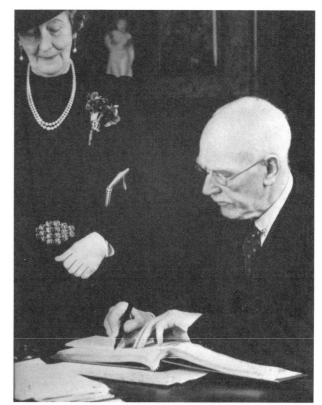

Sir William Burrell signing the Deed of Gift in 1944, with his wife, Lady Constance, beside him.

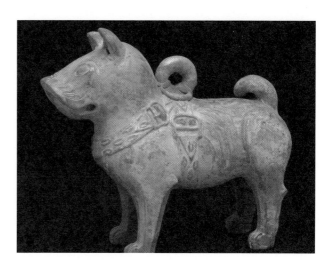

Model of a watchdog
Earthenware covered with a lead glaze
Eastern Han dynasty, AD 25–220

The dog would have been one of many items made as burial goods to accompany the deceased in the afterlife. In Northern China dogs were believed to be the bringers of rice, so it is possible that it is a symbol of eternal sustenance.

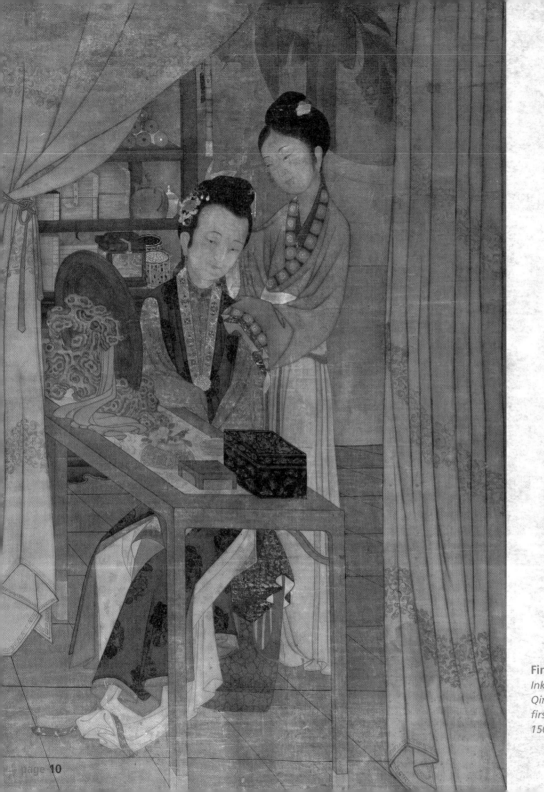

Finishing the Coiffure
Ink and colours on silk
Qing dynasty (1644–1911),
first half of the 18th century
150 x 96.6cm

Sir William Burrell purchased this painting from London dealer John Sparks in 1936 and it is the only example of a Chinese painting in the Collection. There is no record as to why Sir William bought the piece, although the subject, which is rich in detail, may have appealed to him. We have the original sales advert which Sir William must have kept as a memento of his purchase.

Through the device of a parted curtain we get a glimpse of the room of a wealthy lady whose hair is being dressed by her maid. On the table in front of her are cosmetic boxes, a small flower vase, and a mirror and stand. The mirror would have been of bronze, with a polished surface on one side and a small handle for holding the mirror on the other. The long piece of silk, which can be seen hanging from between the knarled wood stand and the back of the mirror, would have been attached to the handle. Many women of wealthy families in China were highly educated and could paint, write calligraphy, and compose poetry. These marks of status are indicated in the painting by the cabinet at the back of the room on which books, scrolls and related objects are displayed. The moon-shaped window looks out on a garden where plantain, or banana, leaves can be seen, symbolic of scholarly activities.

Although the artist is unknown, it belongs to a group of paintings that show beautiful women (*meiren*). The most famous of these are the *Twelve*

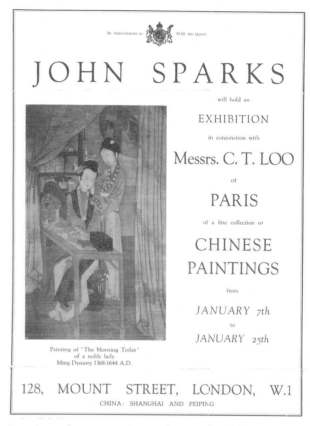

Page insert from an auction catalogue, advertising the painting.

Beauties of Yuanmingyuan, a series of 12 life-size paintings produced by court artists for the Yongzheng Emperor (1723–35), and which were displayed in one of the gardens of the Imperial Summer Palace complex near Beijing. Although most Chinese paintings are mounted as scrolls, this example would once have been mounted as a screen within a solid framework (much as it is framed today), indicating that it too might have been one of a series of beautiful women.

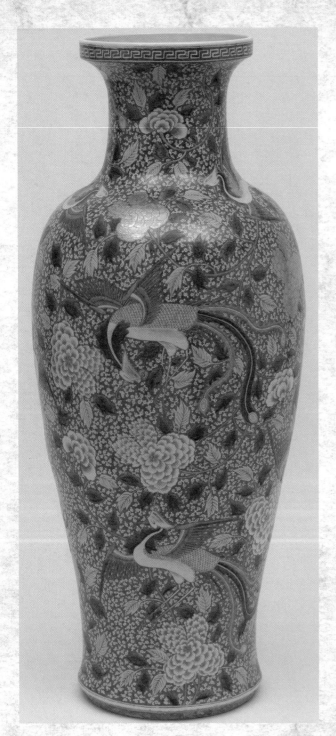

Vase
Porcelain decorated with overglaze enamels
Qing dynasty (1644–1912), late 19th century

Vases like this became popular in the West in the mid
to late nineteenth century. Their size made them suitable
for display in the halls and drawing rooms of large country
houses of the late Victorian period. They were also popular
at the Chinese court, where they were used in the various
informal rooms within the Palace. Although the phoenix
was an emblem of the empress, ranking second out of the
four supernatural creatures, it was a familiar decorative
emblem in China and symbolized peace and prosperity.
The other supernatural creatures are the dragon, the
tiger, and the tortoise.

450 A GLASS HAIRPIN END in the form of a swan, modelled in white iridescent glass, 2.4 *cm.*; *T'ang Dynasty*; and a Bead of calcified glass, the tubular body with blue and white knobs in relief, 3.5 *cm.*; *period of Warring States* 2

Moss £7

451 A GOOD GLASS BEAD of dark blue paste, decorated in relief with knobs formed by the addition of layers of blue and white glass, five rosettes around the centre of the body, 2.5 *cm.*; and an attractively modelled Hairpin End in the form of a bird in white calcified glass ornamented with light blue and brown, 3.5 *cm.*; *period of the Warring States* 2

** The bird illustrated in "Far Eastern Glass; some Western Origins" by Prof. C. G. Seligman and H. C. Beck in Stockholm Bulletin, 1938, no. 10, pl. 7, fig. 4.

Sedgwick £12

452 A BUTTERFLY finely moulded in light blue iridescent glass, slight staining on the top and on the underside but generally in fine state of preservation, 3.5 *cm.*; *perhaps T'ang Dynasty*

** See an important article on "Early Chinese Glass" by W. B. Honey in the Burlington Magazine, November, 1937, p. 211, and cf. pl. 1, fig. f.

ichael £6 ¹⁰⁰

453 A FINE HAIRPIN END in the form of a dragon's head, in beautiful blue iridescent glass, fitted to a perforated bone socket painted light blue, perhaps the end of the original pin, 4*in.*; *? T'ang Dynasty*

[*See* ILLUSTRATION]

Holmes £18

454 A RARE AND IMPORTANT GLASS SCALE of narrow oblong shape, in calcified light blue opaque glass, divided into ten units by five panels of diamonds and lozenges moulded in the paste, 9*in.* long, ¾*in.* wide; *Han Dynasty*

[*See* ILLUSTRATION]

...nk £38.

Auction house catalogue entries with
Sir William Burrell's notes.

HIDDEN SECRETS
FROM CHINA'S SOIL:

Exploring ancient pottery

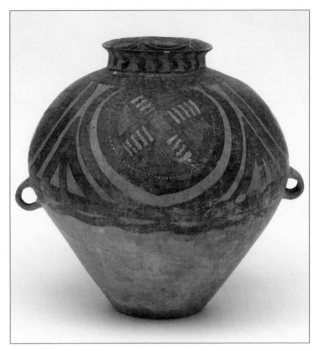

Burial urn
Earthenware with unfired mineral pigment
Neolithic period, Yangshao culture, Machang type, *c.*2,500 BC

Archaeologists have subdivided the Neolithic Yangshao culture of northwest China into different sub-groups. This urn belongs to a related culture called Machang. It is decorated with panels of cross-hatching, perhaps in imitation of basketry, fishermen's nets, or embroidered textiles. Such urns were used as storage vessels in Neolithic burials.

eramic technology in China dates back at least 9,000 years. Only the use of primitive stone and bone weapons and tools predates it. From prehistory, ceramics have held a central position in defining Chinese culture. For thousands of years these earthenwares were buried in the earth, and their reappearance sheds light on the way of life and beliefs held during the Neolithic period (4800 BC–1900 BC), as well as revealing their enduring artistic quality.

Some of the best-known early Chinese pottery in the West dates from the later Neolithic period (*c.*2500 BC) in northwest China, known as the Yangshao culture. They are all burial urns, made for the storage of grain such as millet, intended to provide food for the dead in the afterlife. Formed of simple clay, these urns were made using the coiling method, as the potter's wheel had not yet been invented. The clay was coiled into rings, which were then used to build the vessels from the base upwards. A pad and beater would then have been used to smooth the coils on the interior and exterior of the finished piece. Because the clay was relatively unsophisticated, the firing temperature was low (800–1000 centigrade), resulting in an earthenware that was relatively light in weight. After firing, the earthenwares were painted in three principle colours of brown, black, and red, using mineral pigments, and then burnished to create a subtle and attractive sheen. The painted designs may have pictorial or linguistic meanings, or be linked to communication with the gods. Nobody yet knows exactly what their significance might be.

Although China's ceramic making tradition is an ancient one, very little was known about these early

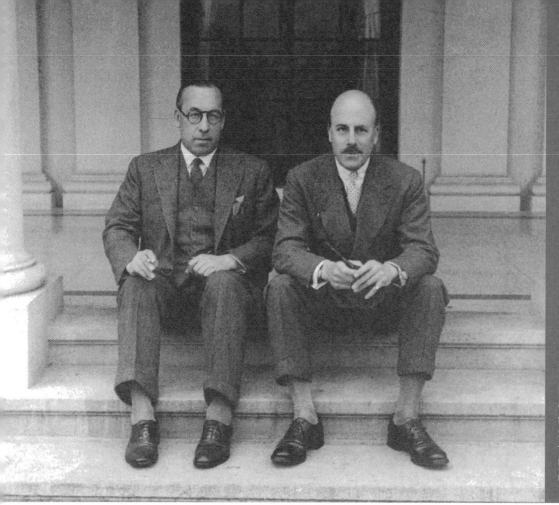

Neilage Sharp Brown (left) and Warren Swire of the shipping firm John Swire & Sons Ltd. They are sitting on the steps of Hazelwood, Butterfield & Swire's manager's residence in Shanghai.

wares until the 1920s and 30s. One reason was that the wares were buried in tombs; another reason was that although ceramic making had a long tradition, these burial urns had no intrinsic value, unlike jades and bronzes, for example. In addition, they were not traditionally collected by Chinese connoisseurs. After the fall of the Imperial system in 1911, when China was opened up to Western involvement, this led to a great interest in the origins of Chinese society. Although the Chinese were aware of their early past, they had no word for 'archaeology', and it had to be invented – *kaoguxue* (literally, the study of ancient things). It was at this time that a number of European and American collectors and museums began to acquire artefacts that had not been seen outside China before. They only came to light during the first few decades of the twentieth century, when European and Japanese railway construction disturbed the large number of tomb sites situated in Northern China.

Neilage Sharp Brown, a Glasgow man who had worked as a shipping clerk in Hong Kong and Shanghai in the 1920 and 30s, was the original collector of most of the Neolithic wares that are now in the Burrell Collection. We do not know for certain whether Mr Brown and Sir William knew each other, but as they both came from a shipping background, they may perhaps have met.

Brown spent most of his life in China, and built up a considerable collection of Neolithic earthenwares through contact with local dealers and collectors. As there were not many local archaeologists, a Swedish archaeologist, Dr Johan Gunnar Andersson, was brought in to advise the Chinese government and in 1921, Andersson discovered the first Neolithic site in Gansu province, northwest China, and went on to uncover and plot 50 Neolithic villages and burial grounds. Brown was an enthusiastic visitor to these sites and was a friend of George Findlay, one of Andersson's colleagues. Several of these earthenwares would have been picked up on site at Andersson's excavations.

Sadly, in the early 1940s when Brown returned to Britain, he was committed to an asylum, and his collection was sold at three auctions at Sotheby's in London in 1944. At the age of 83, Sir William Burrell bought a large number of Neolithic earthenwares at these sales. The ceramics are some of the oldest in his collection. By the end of his collecting days in 1954 aged 93, he had purchased a total of 46 Neolithic earthenwares.

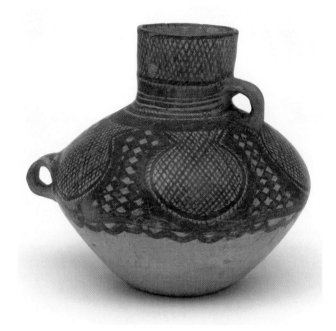

Burial urn
Earthenware with unfired mineral pigment
Neolithic period, Yangshao culture, Banshan type, c.2,500 BC

Banshan is another sub-group of the Neolithic Yangshao culture of northwest China. The shape of this rare two-handled burial jar is very unusual. The position of the handles suggests that this urn was designed as a pouring vessel and would have been made for burial. The geometric ground pattern is relieved by motifs around the shoulder that imitate the shape of burial urns with long necks.

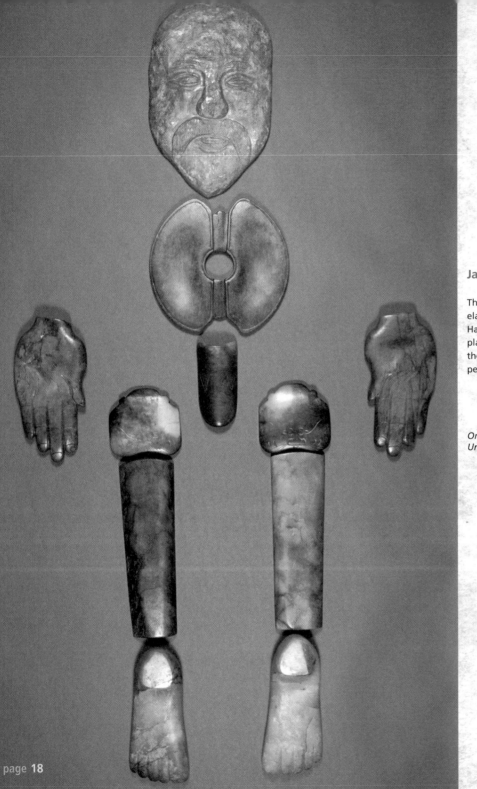

Jades

These single pieces of carved jade were part of an elaborate burial custom that took place during the Han dynasty (206 BC– AD 220). These jades were placed on the deceased to comfort the *po* part of the human spirit that remains on earth when a person dies.

On loan from the Oriental Museum, University of Durham.

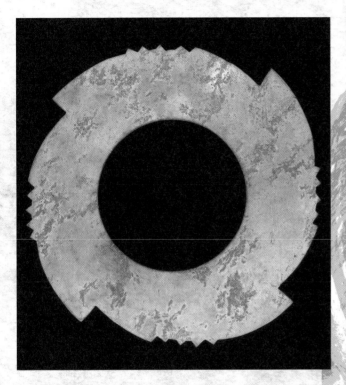

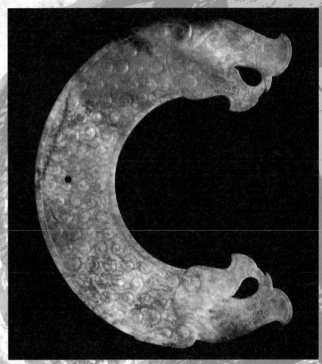

Notched disk (*xuanji*)
Nephrite jade
Neolithic period, Longshan culture, c.2,500–2,000 BC

The Longshan culture was situated in northeast China, in present-day Shandong Province and was one of two jade-using cultures in Neolithic China. Like ceramics in the Yangshao Culture and bronze in later dynasties, jades were used as burial items as part of rituals and as status symbols. This disk has no obvious function, although its complex shape, making it difficult to carve, must have carried an important meaning now lost to us. Perhaps it is associated with astronomy, rituals or warfare.

Pendant in the form of a dragon
Nephrite jade
Shang dynasty, c.1600–1027 BC

Jade pendants were frequently made in the shapes of birds, fish or dragons and were probably used individually and as part of a group of pendants strung together. Although pendants were buried with their owners, it is likely that they were also worn as either decoration or as symbols of rank during the lifetime of their owners.

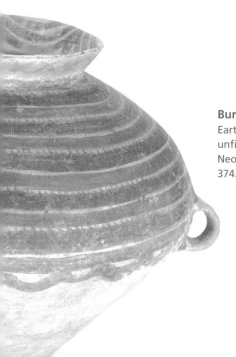

Burial urn
Earthenware decorated with
unfired mineral pigments
Neolithic period, c.2500 BC
374.6 x 470 cm

China's Neolithic period began somewhere around 6,500 BC with the so-called Peiligang culture. This developed in the central-northern and north-western part of the country – the present-day provinces of Henan, Shanxi, Shaanxi and Hebei. Even at this early date, pottery vessels in the form of storage jars and figurines were utilized as everyday items and as burial goods. The Yangshao culture, a later Neolithic phase dating from between seven and five thousands years ago, produced pottery vessels of some sophistication both in terms of construction and decoration.

This example, from the Banshan phase of the Yangshao culture from Gansu Province in north-west China, is typical in that it is made by building up coils of reddish clay to create the form, which have then been smoothed out and fired at a low temperature (800–1000 degrees centigrade). Red and black mineral pigments have been added to form the decoration, which would have been burnished to create a polished surface. While this particular urn has its decoration in horizontal bands, it is very common to see bands forming a swirl pattern or in imitation of basketwork. Because urns like this were used for burial, only the upper half is decorated.

Sir William Burrell bought this and a group of similar urns from the dealer Bluett & Sons, London, in 1948. This piece cost him £85 and was part of the Neilage Sharp Brown collection.

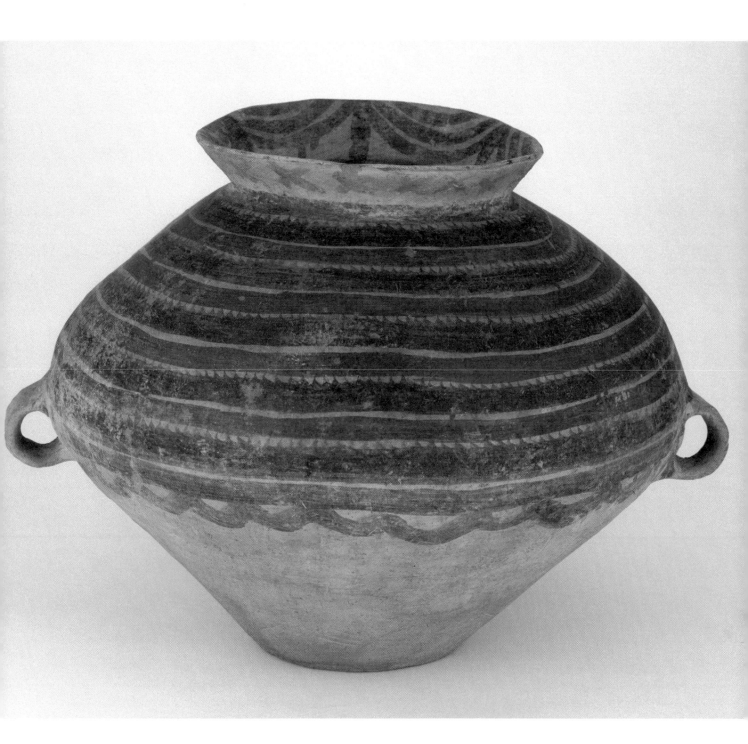

COMMUNICATION BETWEEN HEAVEN AND EARTH

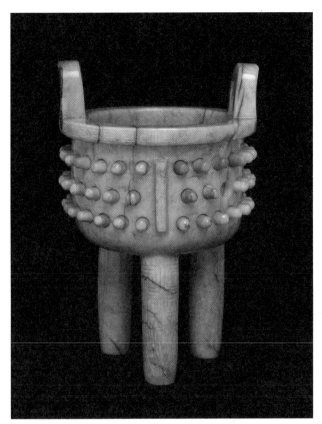

Incense burner
Nephrite jade
Song dynasty, AD 960–1279

The discovery of ancient burial sites and the recovery of bronze vessels during the eleventh and twelfth centuries encouraged Chinese scholars to collect and research these finds. From this time on, early bronzes and other ancient artefacts became sought after collector's items. This interest in the past stimulated a market in copies in bronze and in other materials such as jade. This vessel has been carved to imitate a bronze ritual cooking vessel called a *ding*, although this piece would have been used as an incense burner for a scholar's desk. Its antique shape would have held significant associations for its owner.

The bronzes pictured here date back to the two earliest historical dynasties of China – the Shang (*c.*1700–1027 BC) and the Zhou (1027–256 BC). Many of these bronzes were excavated from the foundations of ancient temples, and burial and ritual sites. When a person of high status died, a lavish tomb was constructed and decorated to ensure immortality and safe passage to the afterlife. Intricately cast bronzes, along with other precious items such as jades, were placed near the coffin to provide comfort and protection for the deceased in the next world. Such bronzes would also have been used in the owner's lifetime in rituals associated with veneration of the ancestors, and their number and size would have reflected their wealth and status. The ritual bronzes in the Burrell Collection are of four main types: food vessels, wine vessels, water vessels, and musical instruments. The collection of 184 Chinese bronzes of 12 different types is considered to be one of the best in Britain.

Bronze technology was first developed in China around 1500 BC and it is interesting to note that while the Chinese were mainly using bronze to make ritual and ceremonial vessels, the West's main use was for warfare. As an expensive material – an alloy, made up of a mixture of tin and copper – it was quickly monopolized by the ruling kings. They strictly controlled both the smelting and casting, and determined who owned such symbols of power and status. Not surprisingly, these bronzes became venerated objects, both at the time they were made and for later generations of Chinese who rediscovered and then collected them. Indeed, during the Song dynasty (AD 960–1279), when scholars became

particularly interested in the past and in early artefacts, bronzes became highly desirable collector's items, which they continued to be in later dynasties and up to the present day.

Bronze casting in China developed from the skills learned from ceramic making. A clay model of the shape of vessel required would first be made, complete with incised decoration. Wet clay would then be wrapped around it and cut off in sections when dry. The inside of the sections would retain the decoration from the model. These sections would then be reassembled around a ceramic core of the same shape with spacers placed at intervals to separate the core from the outer sections. It was then turned upside down and molten bronze poured in between the space. When set, the outer mould would be broken away to reveal the cast vessel. Many of these bronzes today have a blue-green coloured patina, or sheen, caused by the bronze reacting with the earth while it was buried. This appearance was greatly prized by later Chinese collectors, who saw it as evidence of antiquity and a direct link with the past.

The rulers of ancient China communicated with their ancestors through elaborate ceremonies in which bronzes played a part. Guidance would have been sought from an oracle, or priest, on such topics as politics, weather, childbirth, hunting, warfare and health. The shoulder blades of cattle and tortoise shells were used as a medium through which to communicate. The ancestors would be asked a question, the oracle would make notches on the bones or shell, and then heat would be applied to the bone or shell until it cracked. From the direction of the cracks, the oracle could tell whether the answer

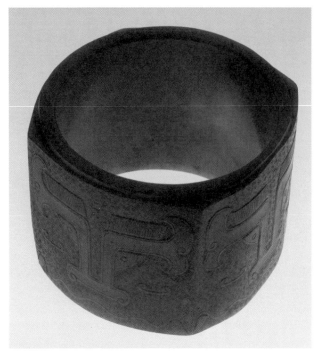

Carved cylinder (*cong*)
Nephrite jade
Neolithic period or early Shang dynasty, *c.*2,000–1,200 BC

Carved from a single block of jade, this *cong*, or carved cylinder, is completely hollow. Found originally in burial sites of the southeast jade-using Neolithic culture of Liangzhu, *congs* can range in length from about one centimetre to more than one metre. Their function in ancient burials is not clear, but the square form has been regarded as the symbol of the earth, while the hole in the centre may symbolically represent the connection to heaven.

was 'Yes' or 'No'. Sometimes the priest would write the answer on the bone.

During the 1850s, farmers in northwest China began to unearth peculiar bones with very polished surfaces marked with oval notches and t-shaped cracks. One of the farmers, a man named Li, saw an

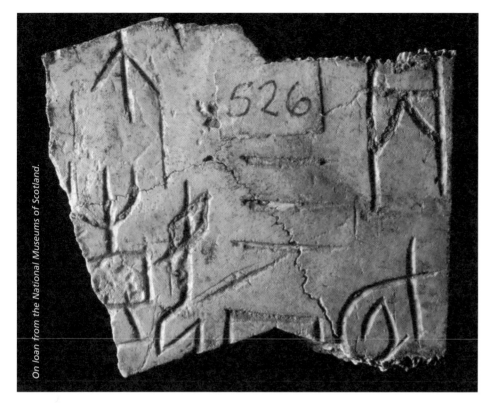

On loan from the National Museums of Scotland.

Oracle bones

This oracle bone is from the Couling-Chalfant collection of oracle bones, gathered in China during the early years of the twentieth century. In 1909, the National Museums of Scotland (NMS) were presented with 1,777 pieces. The rest of the collection is in the British Library and Cambridge University Library.

opportunity to make money and began to sell these as 'dragon bones' to apothecaries. For over 30 years apothecaries ground these bones into powder and prescribed them to cure nervous complaints.

In 1899, quite by chance, a Chinese antiques collector noticed some unpowdered 'dragon bones' in an apothecary's shop and realized that the curious marks upon them were early forms of writing. Archaeologists searched for the source of these bones, and found and excavated a pit filled with 17,000 bones, a complete and undisturbed archive from thousands of years ago. The scapulas of oxen and sheep and tortoise shells had been tied together in

layers by string, and the skeleton of the librarian, a human sacrifice, was still lying on top of his archive. It would have been considered an honour to be sacrificed in this way.

These links with the ancestors continue today in many modern day Chinese societies. People still actively worship, and consult fortune sticks, the modern versions of oracle bones, in temples. Bronze vessels continue to be used in temples, although they are rarely placed in burials, and their particular shapes are often replicated in other materials such as porcelain and jade – confirmation of the symbolic importance of these ancient forms in Chinese culture.

WINE VESSEL (YOU)

The Shang dynasty (c.1600–1050 BC) marked an important phase in China's history. Two inventions in particular were made at this time that would have a significant impact on the country's political and cultural future. One was the development of the written script; the other was the development of bronze technology. A written language aided rapid communication within a centralized political state, while the utilization of bronze enabled the Shang kings to control this valuable material through the casting of vessels that would be used as symbols of

Wine vessel (*you*)
Cast bronze
Shang dynasty, c.1100 BC
22.8 x 17.7 x 18.3 cm

wealth, power and status and as a way of communicating with the spirit world.

Although it is likely that the use of bronze (an alloy of tin and copper), was introduced only gradually, the objects that have survived from this period indicate a very sophisticated use of casting techniques. This vessel, called a *you*, was one of a set of vessels used for serving wine at a ceremonial banquet or as part of a sacrifice to the ancestors. This ancient stylistic bronze wine container with a decorated buffalo head swing loop handle would originally have had a cover. Other vessels of different shapes would have been used for serving different foods and water. The production of these vessels was closely controlled by the royal household, who gifted sets to their followers as a sign of political patronage. When the owner died, their bronzes were buried with them as evidence of their wealth and status and as a means by which they could continue to offer sacrifice for the benefit of the family in the afterlife.

While burial ensured the survival of these bronzes for future generations, it also transformed their appearance. The bluish-green encrusted surface, or patina, was caused by burial underground, a corrosive effect that was greatly admired by later generations of collectors in China. The main body of the vessel is decorated on each side with a large three-dimensional animal mask motif with sculpted curved horns in relief. It is called a *tao tie* (literally, 'evil averting'), and although its meaning and symbolism is something of a puzzle, it is likely that the mask was seen as a protection from evil.

Sir William Burrell bought this *you* from dealer Frank Partridge & Sons for £500 in 1938.

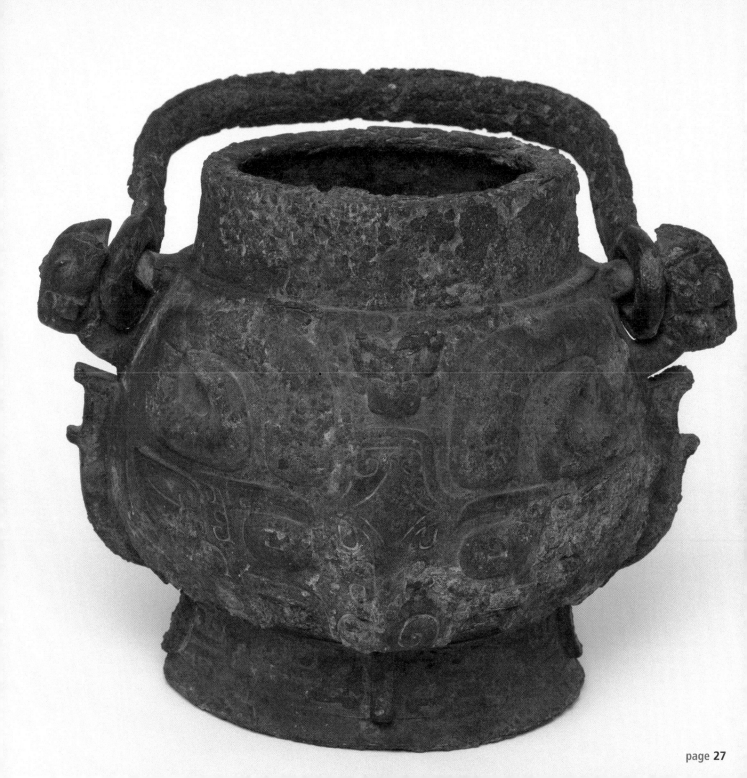

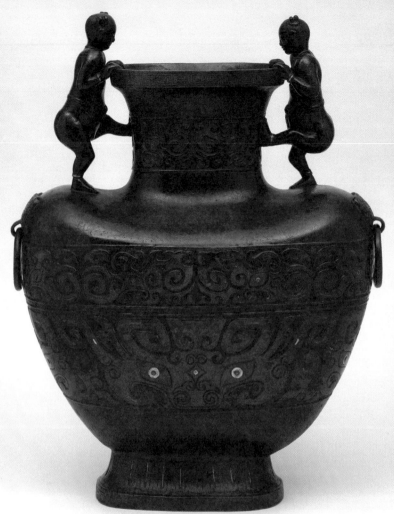

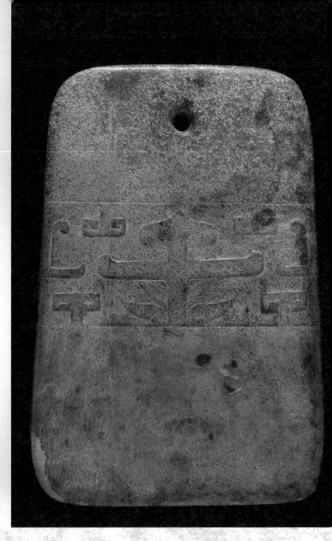

Vase
Cast bronze
Ming-Qing dynasty, 17th–18th century

The interest in ancient bronze forms began during the Song dynasty (AD 960–1279). Later bronzes like this example very often mixed many earlier styles together to create a hybrid form. Therefore, while there is no comparative early bronze shape that is copied here, the *tao tie* monster mask is an earlier manifestation, as is the use of gold and silver inlay in the decoration. The two small boys that form the shape of the handles symbolize fertility.

Axe head
Nephrite jade
Shang dynasty, c.1600–1027 BC

Used more as a ceremonial object than as a weapon, this jade axe head is unusual because of the carved motif, called a *tao tie*. The *tao tie* mask motif is usually found on bronzes of the period and is believed to be a protection from evil.

Wine vessel (*gu*)
Cast bronze
Shang dynasty, c.1600–1027 BC

This *gu*, or wine vessel, was originally made to contain wine to be poured onto the ground in honour of the ancestors. It would have been one of a set made for use in ritual banquets in honour of the ancestors. Other sets of bronzes would have included cooking and serving vessels for different kinds of food, for warming wine and for serving water. Bronzes of this kind were buried following the death of their owner.

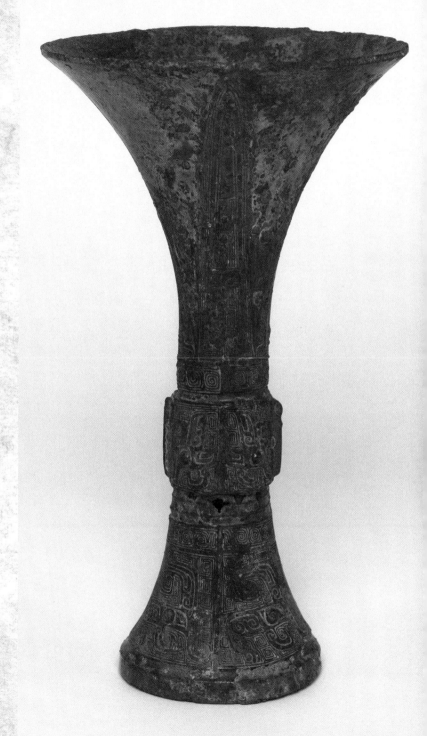

THE ARRIVAL OF PHILOSOPHIES AND RELIGIONS IN CHINA

O ver the centuries the Chinese have developed a polytheistic tradition of religion, where different gods are worshipped for different purposes. An enormous variety of beliefs, practices, gods and heroes have arisen from the three major Chinese religions and philosophies of Confucianism, Taoism and Buddhism. The deities represented here provide an interesting insight into the colourful belief systems of China.

It was not until the late nineteenth century that the words for religion and philosophy entered into Chinese vocabulary, probably through the Japanese language. Until then, religion and philosophy had been so integrated into daily life that separate words had not been needed. Even today, the shrines, temples, altars, and other places of worship found everywhere in China remain a visible expression of a vibrant religious life, and most Chinese people will celebrate several festivals throughout the year. In between festivals, many Chinese also purchase joss sticks, paper 'money' to burn in honour of their ancestors and the gods, and various objects for home and temple devotion. There are shops that sell only these items, and also 'god shops' where you can buy a Buddha or a Guanyin (see p. 33), the Goddess of Compassion. Almost every Chinese home has a religious shrine, containing a spirit tablet to the ancestors and pictures and figures of many household gods.

During the period known as the Warring States (475–221 BC), when China was split into seven different states each fighting for overall control, the 'Hundred Schools of Thoughts' emerged. This refers to the number of different philosophies, or schools, that developed during this time. The two major schools

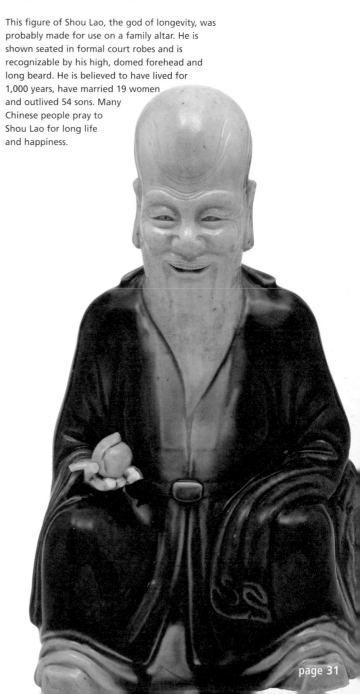

Figure of Shou Lao, the god of longevity
Porcelain decorated with overglaze enamels
Qing dynasty, 17th century

This figure of Shou Lao, the god of longevity, was probably made for use on a family altar. He is shown seated in formal court robes and is recognizable by his high, domed forehead and long beard. He is believed to have lived for 1,000 years, have married 19 women and outlived 54 sons. Many Chinese people pray to Shou Lao for long life and happiness.

which emerged and which continued to influence Chinese thought were Confucianism and Taoism. Confucianism, developed by the philosopher Confucius (Kongfuze, 551–479 BC), was an ethical system of government based upon the idea that the universe is regulated by order. Education was at its core, as were the Five Virtues of benevolence, justice, propriety, wisdom and sincerity. Taoism, the only religion indigenous to China, preached almost the opposite. Supposedly developed by Laoze (literally, 'old boy', b.604 BC), many of its ideas are based upon magic, alchemy and geomancy (a form of divination). Laoze taught that man should not strive, but should pursue a course of inaction as things will come to a successful conclusion without effort. Both Confucianism and Taoism were seen by the official class who governed China for centuries as complementary – Confucianism for official life, Taoism for times of leisure.

Taoism in particular has contributed much to the poetic and artistic imagery of China. The Eight Immortals featured here (see pp 34–35) are part of the Taoist canon of gods. Each of the Immortals lived at a different time in history and obtained immortality by their deep spirituality and understanding. They all have different powers and each has a different emblem, such as a flute and lotus flower, associated with them. These eight figurines would probably have been placed in a domestic shrine, although there were temples dedicated to Taoism at which priests officiated. In a Taoist ceremony, a host of gods and goddesses would be present. The high priest and several lesser priests would be brought to the temple, all beautifully robed in elaborate vestments with red, the primary colour of good fortune, predominating.

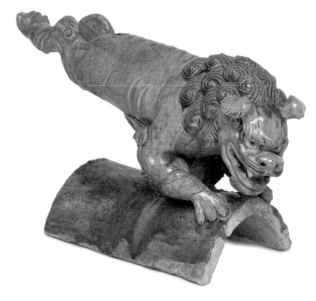

Roof ridge tile
Earthenware with enamel decoration
Ming dynasty, 15th–17th century AD

Human and semi-human figures and animals, like this pouncing ferocious lion, were placed on the roofs of palaces, temples, and homes to ward off evil spirits. Made by using a number of complex moulds and then finished by hand, tiles such as this were the products of specialist workshops that developed in north China during the building of the Imperial City of Beijing in the fifteenth century.

Such rituals would last for three, five, seven or nine days, depending on how much money the townspeople had for the festival. Figures like these continue to be part of Chinese culture, and ceramic models of gods and goddesses can be purchased everywhere in China and in Chinatowns throughout the world.

Buddhism was introduced to China from India

sometime during the first century AD. Fundamentally a religion of meditative training, benevolence and moral vigour, Buddhism did not challenge either Confucianism or Taoism and quickly became integrated into Chinese society, so much so that many of the Indian deities changed dramatically and took on Chinese aspects. A good example of this is Avalokitesvara (the lord who sees everything), called Guanyin in China, who became female and was worshipped as the Goddess of Compassion.

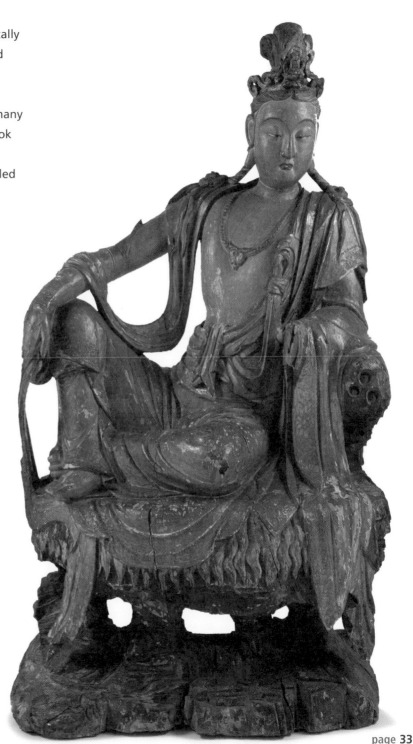

Figure of the Boddhisattva Guanyin
Wood with polychrome decoration
Song-Yuan dynasty, 12th–13th century

Guanyin, or the 'one who hears the sorrows of the world', quickly became a popular Buddhist deity in China, associated not only with compassion but also with childbirth and with sailors and fishermen. It is not unusual to find many altars in temples devoted to Guanyin, while most homes will have a small figure of the Boddhisattva for personal devotion. The ritual of consulting Guanyin continues to be an integral part of the lives of tens of millions of people throughout the East today.

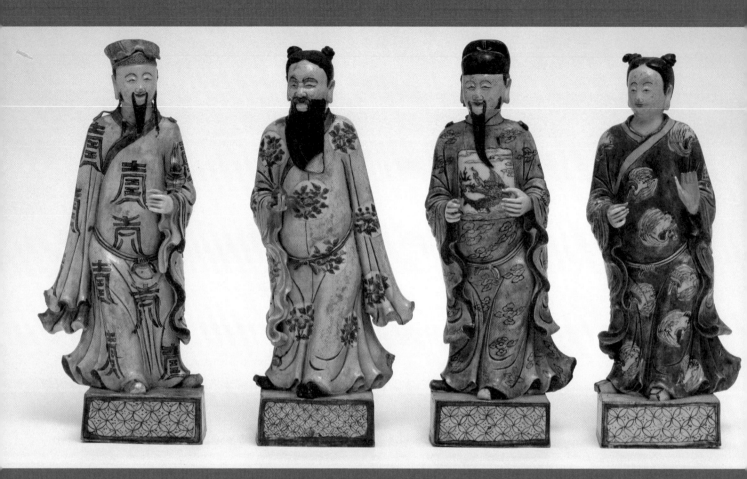

The Eight Taoist Immortals
Porcelain decorated with overglaze enamels
Qing dynasty, 18th century AD

The Eight Taoist Immortals continue to be as much a part of the
popular imagery of China as they are religious deities. Each
attained immortality through a strange set of events and each has
particular supernatural powers. In addition, they all have a
distinguishing emblem, or *pao pei*. Sometimes only the emblem is
used, usually as a decorative motif. Only two of the figures above
still have their emblems. Zhongli Quan is represented by a fan;
Zhang Guolao by a bamboo tube and two rods; Liu Dongbin by a
fly whisk and sword; Cao Guojiu by castanets; Li Tieguai by a
gourd; Han Xiangci by a flute; Lan Caihe by a basket of flowers
and He Xiangu by a lotus.

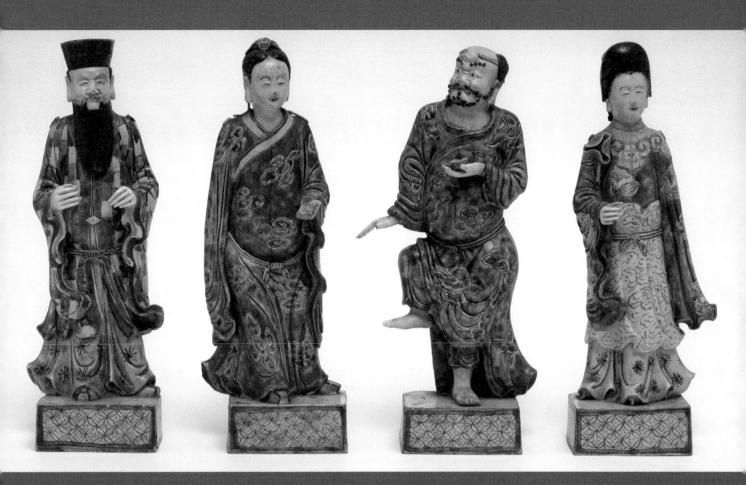

GUARDIAN ROOF TILE

Traditionally, in China the roof of a building marked a point of spiritual communication between heaven and earth. As a result, roof tiles for temples, palaces and the homes of the wealthy were elaborately decorated with motifs that were designed to ward off evil spirits and bring good luck. Tile work became especially significant during the Ming dynasty (AD 1368–1644), when, as a result of the building of the new capital at Beijing, it became a specialist trade centred on kilns in the northern province of Shanxi.

Guardian roof tile
Earthenware decorated with overglaze enamels
Ming dynasty, 15th–17th century AD
45 x 25.4 x 14 cm

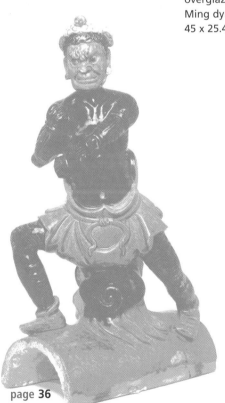

The decorative elements were reserved for tiles on the ridge sections of a roof across the top and where it would sweep down at each corner. Manufactured using moulds, the designs of ridge tiles were of grotesque creatures, animals of the zodiac or mythical characters, facing outwards in a line and in uneven numbers. They provide us with a fascinating insight into how myth has influenced Chinese roof decoration.

The figure on the ridge tile illustrated here may represent Prince Min of the state of Qi, whose disastrous 18-year reign ended with a terrible death in 283 BC. He was supposedly hung on the roof of his ancestral temple for three days on the Prime Minister's orders, and as soldiers walked by, they peeled off his skin and ripped out his tendons. After his death, his successors placed an effigy of him on the roof in order to protect themselves from his evil spirit coming back to haunt them. The figure of Min Wang is still seen on imperial, religious and private buildings in China, and it became the custom to place creatures on the roof behind him to ensure that Min Wang would not escape from his perch. He is often depicted riding on a hen, which, like the cock, can drive away evil spirits. The number of mythical animals behind him came to signify the rank and status of a building.

Even today most Chinese people will have some sort of guardian in their home, whether it be a picture, calligraphy or an ornament on the roof. It is hoped that this will bring luck to the owners of the house, and protect them from evil spirits such as Min Wang.

Sir William Burrell bought this tile for £41 from dealer John Sparks in 1946.

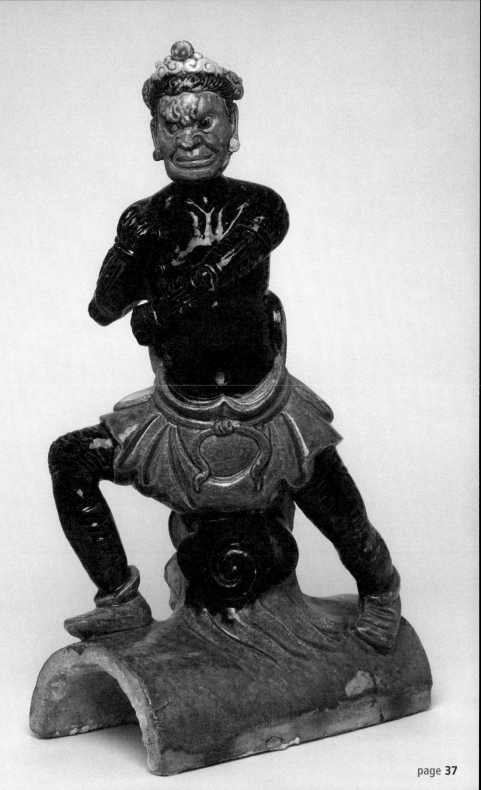

屋瓦

Two temple vases
Glazed earthenware
Ming dynasty, AD 1368–1644 (late 15th century)

These two large vases with double mask
(also known as the *tao tie*, literally 'evil
averting', motif) handles are decorated
with dragons and clouds. Their raised outlines
are filled with coloured glazes.

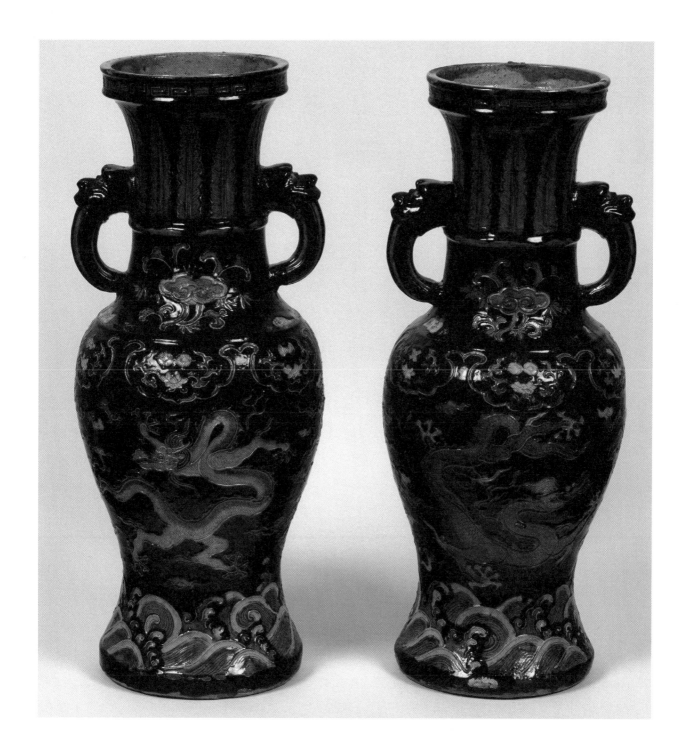

CHINESE TRADE, TRANSPORT AND TREASURES

B urial objects can tell us much about Chinese trade, transport and the treasures that were exchanged along the Silk Road. These figures of animals and humans were perhaps buried with the bodies of important people such as ambassadors and give us an insight into the life of the early Chinese.

During the Tang dynasty (AD 618–907), China became a major centre for trade of all kinds and this influenced Chinese culture, arts and religious beliefs. The Tang dynasty was a period of dazzling achievements in city planning, sculpture and painting, ceramics, metal work and textiles. The first Tang dynasty emperor was Turkish, but claimed Chinese ancestry. Outside influences came via the prosperous overland routes connecting the desert regions of the west to the Imperial City of Chang'an (present day Xi'an). The Silk Road, so called because China's main export for many years was silk, started in Chang'an and continued through Gansu, Qinghai, Xizang, Kashmir, Afghanistan, Iran, Turkey, and on into Europe (see map on p.46).

The burial objects and carved jade pictured here are all from the Tang dynasty, and were made to accompany the deceased into the afterlife. They give us an insight into the luxuries and fashions of the time and depict the various modes of transport used by travellers along the Silk Road. These included horses and two species of domesticated camels native to Eurasia – the single-humped Arabian camel, or dromedary, and the smaller twin-humped Bactrian camel of Central Asia. Horses and Bactrian camels are not native to China, which demonstrates how important the thriving overland trade with the Middle East was at this time.

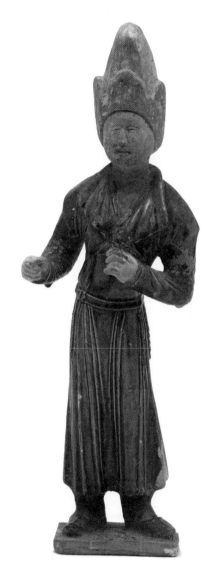

Figure of a falconer
Earthenware with lead glaze
Tang dynasty, 8th century AD

Falconry was a popular pastime for the aristocracy in Tang China, as represented by this burial figure. The falconer also wears Central Asian dress, which is highlighted by the use of *sancai* (three-colour) glazes, used exclusively on burial wares during the first half of the eighth century.

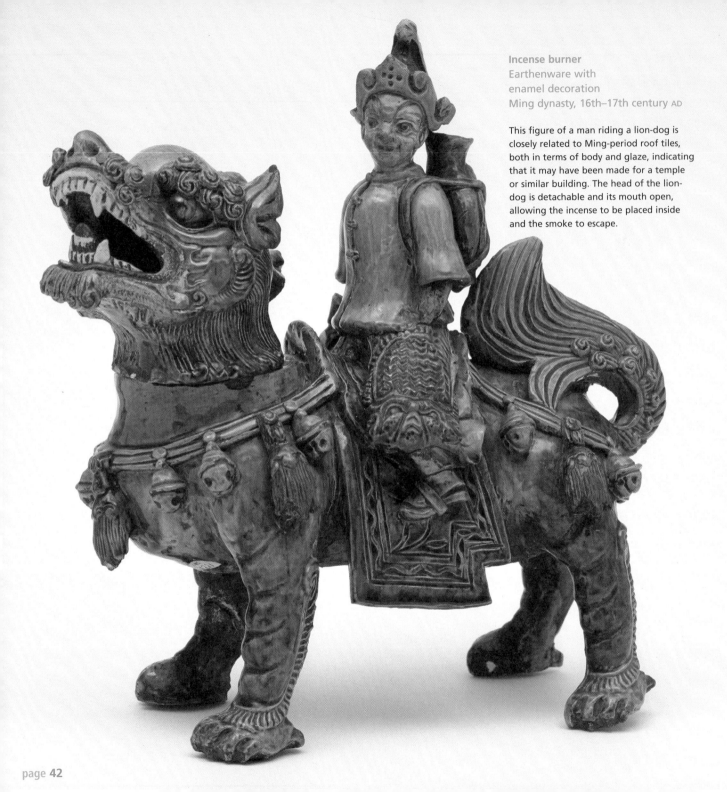

Incense burner
Earthenware with
enamel decoration
Ming dynasty, 16th–17th century AD

This figure of a man riding a lion-dog is
closely related to Ming-period roof tiles,
both in terms of body and glaze, indicating
that it may have been made for a temple
or similar building. The head of the lion-
dog is detachable and its mouth open,
allowing the incense to be placed inside
and the smoke to escape.

Chinese merchants imported jade for carving from Central Asia, glass from Syria, spices from India, pearls from the south and exotic animals such as lions and rhinoceroses for the imperial hunting parks. In return, China exported porcelain, silk and paper.

Chang'an was not only the biggest centre of trade in Eastern Asia, it was also the largest city in the world, with a cosmopolitan population. Foreign merchants from Samarkand, India, and Arabia, ambassadors, Buddhist monks from Korea and Japan, nomads, students, and artists and musicians from Central Asia all flocked to the city, carrying ideas, beliefs and objects that were to profoundly affect the future history, culture and identity of China.

The Chinese during the Tang period were fascinated with the exotic and that may explain why this glazed figurine of a lady is wearing what looks like batik robes and carrying a goose skin filled with wine. She may be selling wine imported from Persia, as this was particularly popular and regarded as a fine rare drink.

Sir William Burrell acquired his first Tang dynasty burial object in 1911, although it was not until the 1940s that he began collecting such objects in earnest. George Eumorfopoulos, a famous Greek collector of Chinese ceramics, gifted a large part of his collection to the British Museum and to the Benaki Museum in Athens. The remaining objects were put up for auction, and Sir William acquired some of them through dealers.

Although Tang burial figures are familiar museum objects today, they were practically unknown before the building of the railways through northern China when large numbers of burial sites were discovered and their contents unearthed. The realistic appearance of the animal and human figures appealed to European collectors in particular as they showed a similarity to the Western sculptural tradition. As with the Neolithic urns, Tang burial objects were not traditionally collected in China.

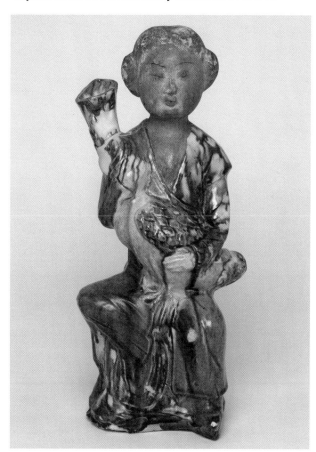

Lady holding a goose
Earthenware with lead glaze
Tang dynasty, 8th century AD

Like the falconer, this figure was made for burial but shows clearly the influences coming westward into China during the cosmopolitan Tang period. The lady is cradling a goose skin that may be filled with wine imported from Persia.

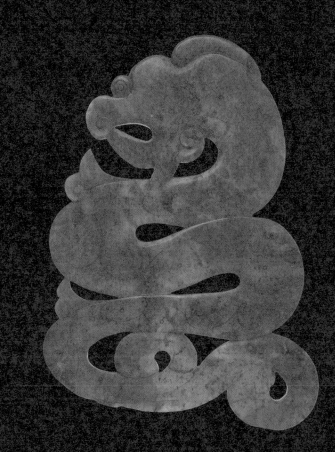

Dragon
Nephrite jade
Ming dynasty, 1368–1644

This single piece of carved
jade is in the form of a
curling dragon. The dragon
is the emblem of Chinese
emperors.

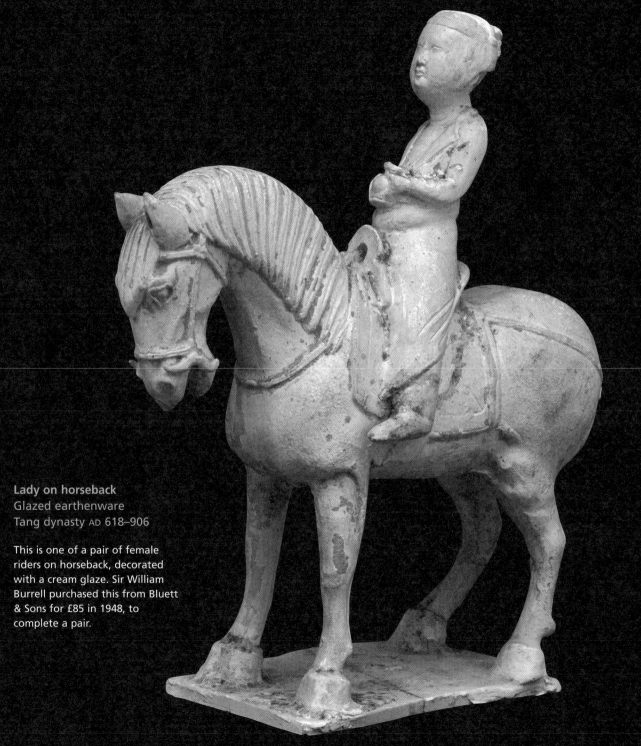

Lady on horseback
Glazed earthenware
Tang dynasty AD 618–906

This is one of a pair of female
riders on horseback, decorated
with a cream glaze. Sir William
Burrell purchased this from Bluett
& Sons for £85 in 1948, to
complete a pair.

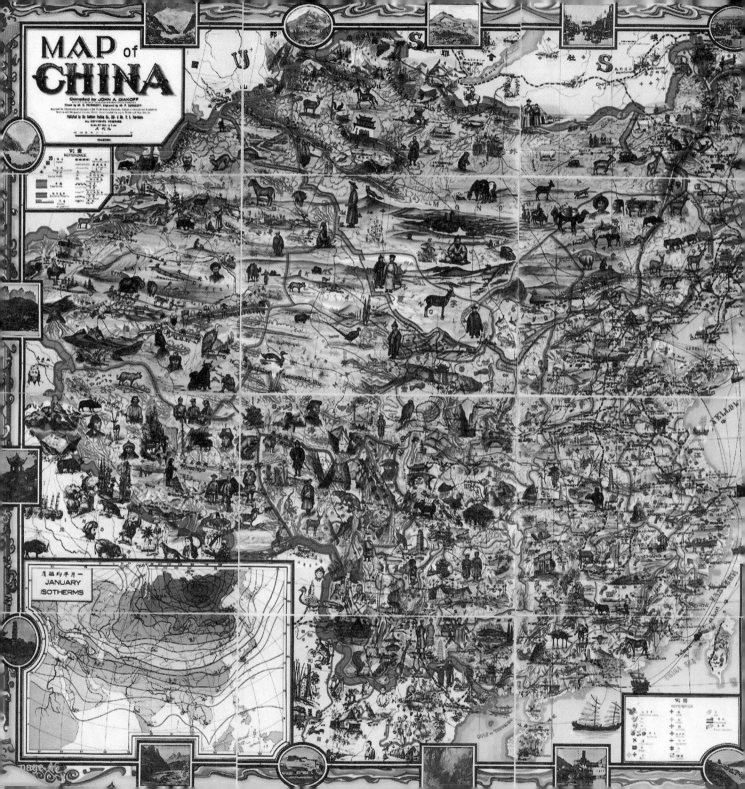

MAP of CHINA

Compiled by JOHN A. DIAKOFF

JANUARY ISOTHERMS

REFERENCE

This hand-painted map was made in China in the 1930s.

Following the end of the Tang dynasty in AD 906, the practice of including earthenware models of servants, camels and horses in tombs of the wealthy gradually declined. Instead, those who could afford it were buried with a wide variety of objects that ranged from silks and precious metals to porcelain.

Some of these tomb objects, such as this

Funerary jar for holding grain
Porcelain covered with a qingbai glaze
Song dynasty, 12th–13th century AD
77.4 x 19.6 cm

funerary jar, had a symbolic purpose. Made of porcelain, it is covered with a glaze that has a slightly bluish tinge (caused by the presence of iron oxide), which the Chinese call *qingbai* (blue-white). It would have been one of a pair that contained rice, or a similar grain, as an offering to the dead. The figures and symbols that surround the neck of the jar represent the star gods standing in a row with the Green Dragon of the East above them. Also present is a tortoise entwined with a snake, symbolizing the Black Warrior of the North. On the cover is the Vermilion Bird of the South. Other jars exist that show the White Tiger of the West in place of the dragon, indicating the importance of protecting the Four Quarters within the tomb.

At the time this jar was made, China was undergoing a period of great intellectual activity, when many of China's greatest poets, writers, historians, philosophers and artists were active. In this period gunpowder, fireworks, printing and porcelain were invented. China's cities were among the largest in the world with a market system for goods well able to supply the needs of its population. Merchants traded ceramics on a large scale, including *qingbai* porcelain, which was popular both in China and abroad. The kilns that produced *qingbai* wares were situated in south China in the city of Jingdezhen, which still produces most of the country's porcelain today. Then, as now, a wide variety of shapes would have been made, ranging from bowls and dishes for the table, to storage vessels and wine pots.

青白

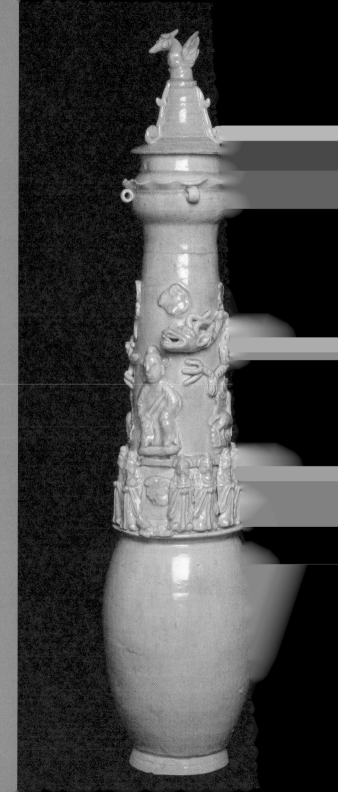

CHINA AND THE WEST

Sir William's fascination with Chinese culture, art and philosophy is reflected in the breadth of his collection, from the Neolithic earthenwares to these seventeenth- and eighteenth-century export wares. He seems to have been particularly drawn to Chinese export wares, although Kangxi wares, which he originally bought, were not at that point considered export wares. They were the first objects he collected and probably led to his interest in other periods of Chinese art. He may have been fascinated by their novelty and individuality, or maybe it was the idea of trade between countries over great distances by sea that attracted him.

The Chinese porcelains featured here were created for both the foreign and domestic markets during the seventeenth and eighteenth centuries. Mass-produced, they were traded for raw materials and luxuries not available in China and were exported over the centuries to Europe, the Near East, south-east, southern and western Asia, and to Japan.

Although the Chinese had been trading indirectly with the West as far back as Roman times, it was not until the arrival of Portuguese ships in East Asia in 1514 that Europeans began to trade with China directly. The major export commodities at this time were spices and raw silk, hugely valuable in Europe – so much so that by 1600, Portugal was joined by the Dutch and two years later by the English as traders with China. Both the Dutch and the English formed East India Companies – stock companies which had the monopoly of trade with the East. By the middle of the eighteenth century, the French, Danes, Swedes and Germans under the patronage of Holy Roman Emperor Charles VI all operated companies which were given permission by the Chinese government to trade out of the port of Canton.

During the seventeenth and eighteenth centuries, porcelain was exported from China in huge quantities, brought back as both company cargo to be sold at auction and as the private cargo of ship's officers and merchants. As a result, it became more and more popular throughout the world. Even so, porcelain was not the most sought after commodity from China in the eighteenth century – this was tea. Most porcelains, whether destined for export or for the home market, were made at Jingdezhen, a city in

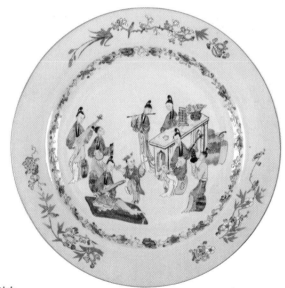

Dish
Porcelain with overglaze *famille rose* enamel colours
Qing dynasty, Yongzheng period, AD 1723–35

The central decoration of a group of musicians joyfully playing music, while the guests are sitting and listening is a typical genre scene found on late seventeenth- and early eighteenth-century porcelain.

This dish is part of the Jack Outhwaite Thompson bequest, bought through the National Arts Collection Fund in 2003.

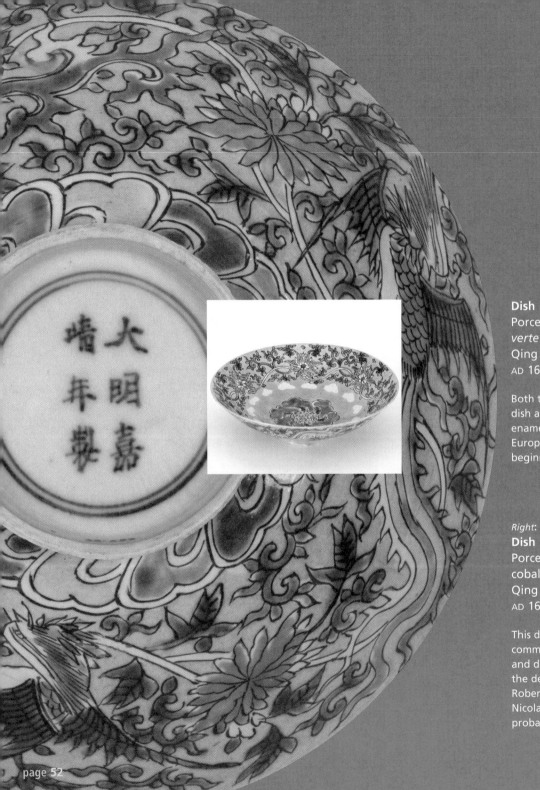

Dish
Porcelain with overglaze *famille verte* enamel colours
Qing dynasty, Kangxi period,
AD 1662–1722

Both the shape and the pattern on this dish are representative of the kind of enamelled wares being exported to Europe at the end of the seventeenth and beginning of the eighteenth centuries.

Right:
Dish
Porcelain decorated in underglaze cobalt blue
Qing dynasty, Kangxi period,
AD 1662–1722

This dish was made as a specially commissioned piece for export to Europe and dates to about 1700–10. The source of the decoration is from a series of designs by Robert Bonnart and engraved by his brother Nicolas, illustrating the senses. This one probably illustrates the sense of smell.

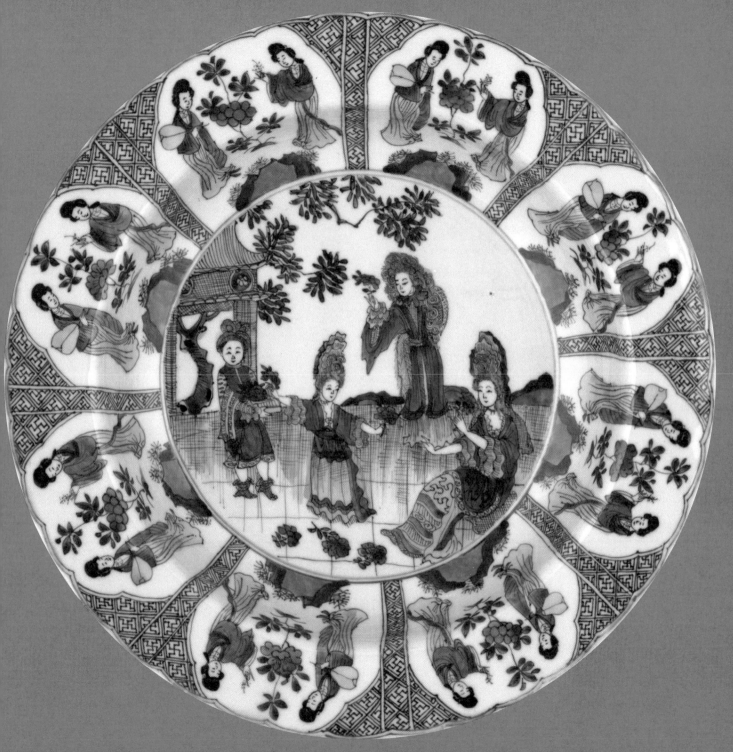

southern China devoted entirely to porcelain manufacture. Here, where there was a plentiful supply of the raw material necessary to make porcelain – porcelain stone and china clay – thousands of skilled potters, kiln workers and helpers made and decorated millions of pieces a year under workshop conditions. By the beginning of the eighteenth century, Europeans could request porcelains made in European shapes and with European styles of decoration. This was part of a vogue for Chinese objects that swept through European society at this time. Such pieces were copied from models, drawings and engravings sent out to China with ship's officers and merchants. All this helped to create a fashion for Chinese porcelain in the West during the seventeenth and eighteenth centuries.

The predominant decorative colour on seventeenth-century porcelain was cobalt blue, painted onto the porcelain body before a clear glaze was added and before firing at a high temperature (in excess of 1300 centigrade). In the late seventeenth and eighteenth centuries, enamel colours were added, creating a richer palette. Enamels were applied over a pre-glazed and fired body, which was then fired again at a low temperature to vitrify them. Three enamel palettes became popular: *famille noire, famille verte* and *famille rose*, so named in Europe because of their predominant colours (black, green, and pink, respectively). The *famille rose* style is among the most

successful and enduring innovations of eighteenth-century porcelain, and originally referred to the manufacture of ruby glass in Europe. The Jesuits presented the crimson pink and white enamels that decorate this type of porcelain to the Imperial Court during the Yongzheng period of the Qing dynasty (AD 1723–1735).

White enamel was an important element in the *famille rose* palette. Blending the white with various shades of opaque paints gave the three-dimensional effects favoured in the western style. The so-called 'white on white' technique (white enamel on white porcelain), which had a lengthy history in Europe, was innovatively brought back to life in China. Floral subjects and scenes of women and children decorate many *famille rose* porcelains. Sir William Burrell purchased only one large *famille rose* bowl, in December 1925, but sold it again shortly afterwards. The *famille rose* porcelains featured here form part of the Jack Outhwaite Thompson bequest, bought with the assistance of the National Art Collections Fund and gifted to Glasgow Museums in 2003. It is a highly significant and complementary addition to Sir William's collection.

Bowl
Porcelain with overglaze enamel colours
Ming-Qing dynasty, 17th century

The imagery of horses amidst waves may relate to the magical sea horse, or *haima*, an animal of good fortune which is often depicted carrying the Taoist scriptures on its back.

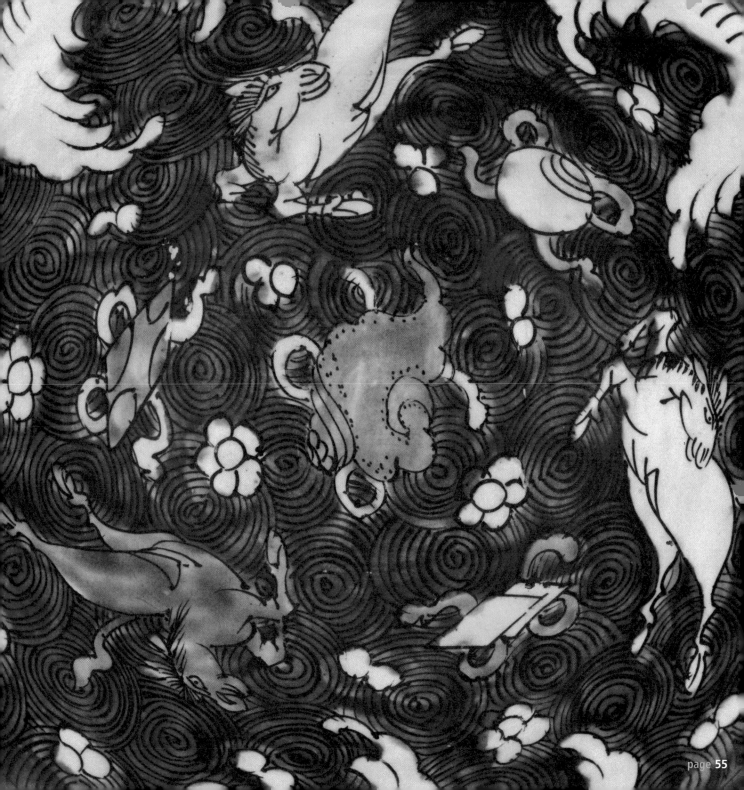

Banners in China are usually made for festivals, as temple hangings and for special celebrations. Although little is known about the origins of this banner, it is likely that it was made approximately 100 years ago for a shop or trading company. The top southern-style Chinese characters translate as 'import and export of foreign goods', while the two central characters are a polite greeting. It may have been used in a parade to promote a company that traded regularly with the West.

The predominant background colour of the banner is red, which represents good luck, and the central section is decoratively rich with dragons, phoenixes and lion dogs, all traditionally auspicious symbols. The upper section has emblems associated with the Eight Taoist Immortals, a group of mythical human spirits who possess magical powers. Their emblems include the lotus, gourd bottle, castanets and sword, which again express wishes of good luck. Both sides of the banner have been embroidered and sewn carefully together, and a loop at the top of the banner has been made for a pole, perhaps for carrying or for displaying. In the centre of the banner there are circles representing heaven, while the overall shape of the banner is square, representing the earth.

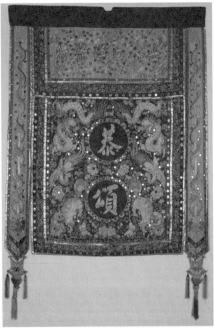

Banner
Silk with gilt thread and
mirrored embroidery
Qing dynasty, late 19th century AD
200 x 150 cm

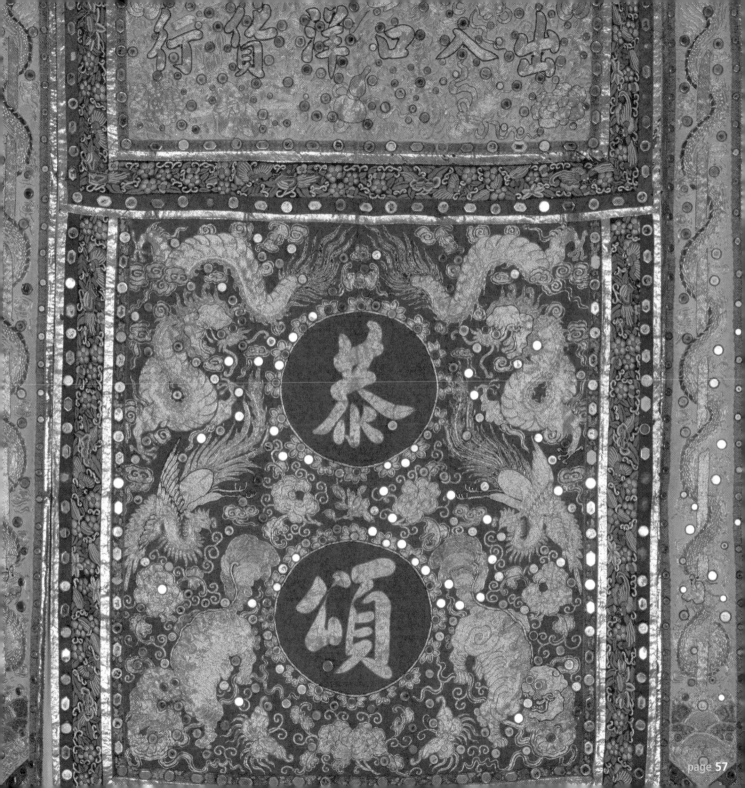

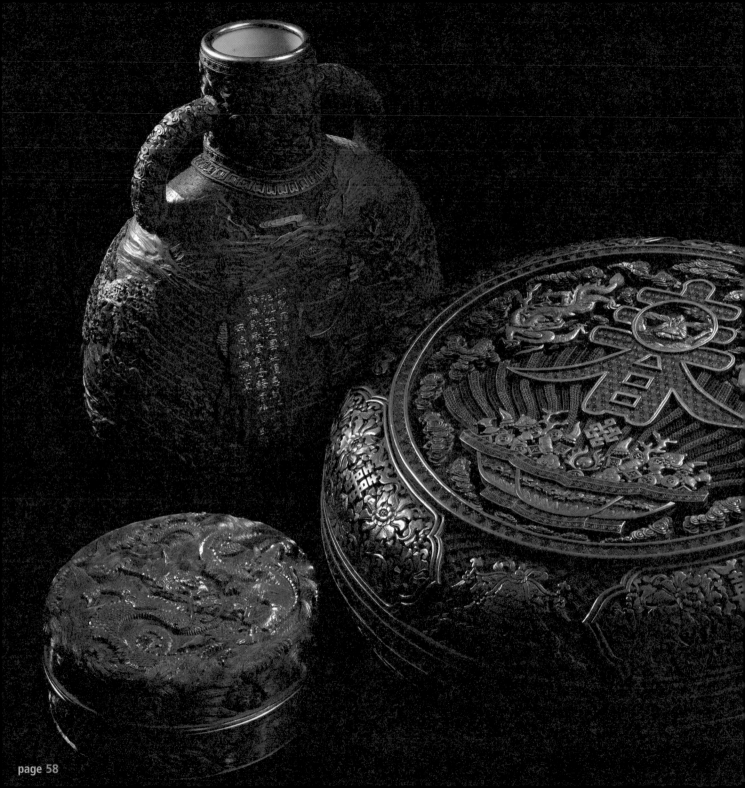

Lacquer wares

China was the first country in the world to
use lacquer. This comes from the sap of a
tree indigenous to China, and when it is
exposed to air it forms a plastic coat. This
can be applied to wood, leather, porcelain,
bamboo and textiles. Individual pieces of fine
lacquer ware can take years to produce,
because of the number of layers involved.
Because of their value, they were restricted
to certain classes and ranks.

Lacquer wares
Moon flask
Carved red lacquer
Qing dynasty (AD 1644–1911)

This flask is made of porcelain with lacquer decoration of
a landscape carved on both sides. An 'imperial' poem has
been carved and gilded on the face of the rocks.

Circular box
Carved red lacquer
Qing dynasty (AD 1644–1911)

This box is decorated with a powerful dragon with
fanglike whiskers. There are only two claws on each foot.
The rims of the box are reinforced by copper bands.

Large circular box
Carved red lacquer
Qing dynasty (AD 1644–1911)

This box may have been a storage container for
documents, jewellery, or even medicinal herbs and
minerals. The Chinese character for 'springtime' is carved
on the lid above a basket of flowers.

All on loan from the National Museums of Scotland.

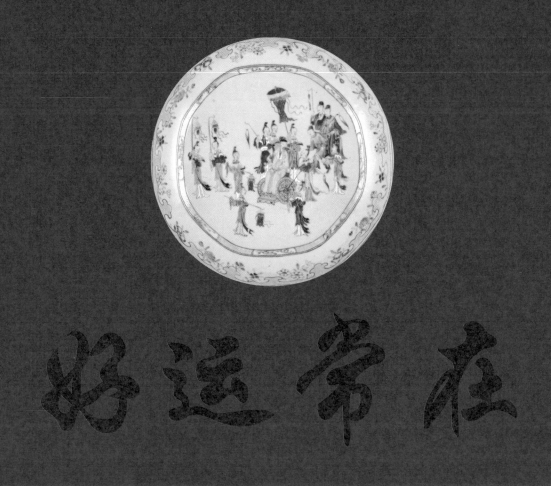

好运常在